STROBIST

PHOTO TRADE SECRETS

VOL. 1

EXPERT LIGHTING TECHNIQUES

ZEKE KAMM

STROBIST PHOTO TRADE SECRETS VOL. 1
EXPERT LIGHTING TECHNIQUES

Published by Peachpit Press. For information on Peachpit Press books, contact:

PEACHPIT PRESS
1249 Eighth Street
Berkeley, CA 94710
(510) 524-2178
Fax: (510) 524-2221

Find us on the Web at www.peachpit.com
To report errors, please send a note to
errata@peachpit.com
Peachpit Press is a division of Pearson Education
Text and illustrations copyright © 2011 Trade
Secret Cards, LLC; all photographs separately
copyrighted by their photographers.

EDITOR: Zeke Kamm
PRODUCTION EDITOR: Lisa Brazieal
PROJECT EDITOR: Rebecca Freed
COVER AND INTERIOR DESIGN: Mimi Heft
COVER PHOTO: Danny Ngan
COMPOSITOR: Zeke Kamm

ISBN 13: 978-0-321-75287-1
ISBN 10: 0-321-75287-2

9 8 7 6 5 4 3 2 1

Printed and bound in the United States

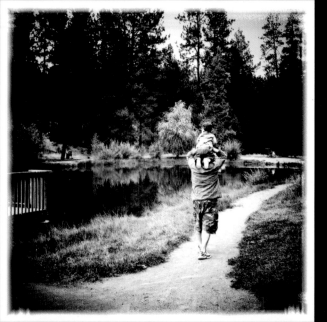

"While passionately photographing life, don't forget to live life passionately."

Photo of author and son taken by wife

INTRODUCTION

PHOTOGRAPHY IS ABOUT light, simple as that. Learning to control light is a critical step in becoming a better shooter.

You are holding in your hands a book of inspiration: The work of two dozen photographers who know how to use light. Flip each page over and see how they created these dynamic photos, so you can make images like this, too.

The very first thing in your tool kit should be a willingness to experiment. *Photo Trade Secrets* is designed to help you do just that.

— David Hobby
Photographer & Editor, Strobist.com

THERE'S A SECRET in photography: Learning how to light isn't hard. It doesn't take thousands of dollars worth of gear. Not even hundreds. You don't need to memorize complex theorems or massive texts.

All you need to light your photos like an expert is a few concepts, a few tools—many you already have, and a few minutes to think about the image you want to take before you take it.

The best thing about the techniques in this collection is they easily scale up or down. Whatever situation you're in, you can use this knowledge to make your photographs better. Tear out an image or technique that inspires you. Bring it to your next shoot. And give it your best shot!

— Zeke Kamm
Editor, NicePhotoMag.com

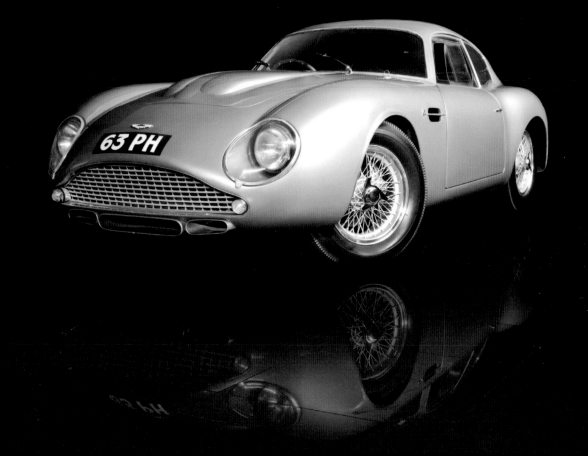

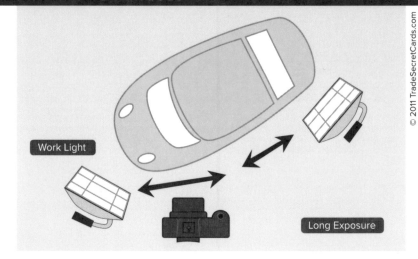

Work Light

Long Exposure

KEN BROWN

61 Aston Martin GT Zagato

THINK YOU DON'T have enough lighting gear to take great images? Ken Brown borrowed a $20 hardware-store work light to photograph this $5,000,000 Aston Martin Zagato. How did he make it look so good with just one light? Working in a pitch-black room, Ken left the shutter open for 21 seconds while he waved the light around the front and down the side of the car, creating a huge virtual softbox. With a little trial and error you can use this technique to get big-budget results for little to no money.

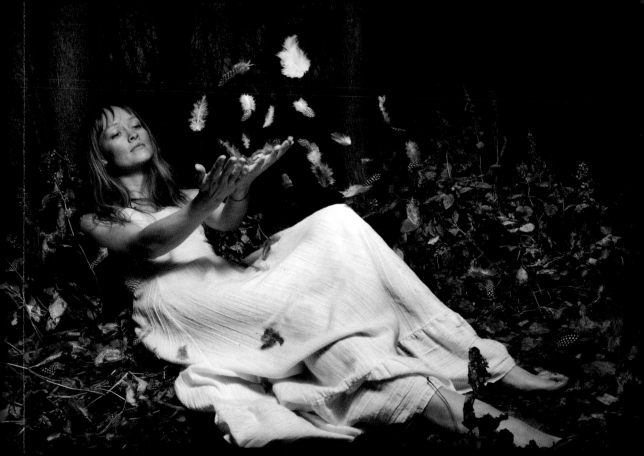

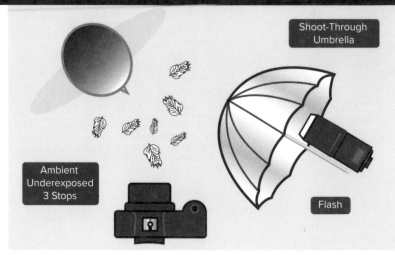

STEPHANIE BELL

Letting Go

WAY BACK IN 2006, Stephanie Bell from Emerging Design & Photography took the image "Letting Go" in her first attempt at off-camera lighting outside the studio. She started by overpowering the daylight with a fast shutter. Then she used a single flash set to full power and blasted it into a shoot-through umbrella. By keeping the ambient light low, she was able to stop the motion of the falling feathers with the flash and create an image worth holding on to.

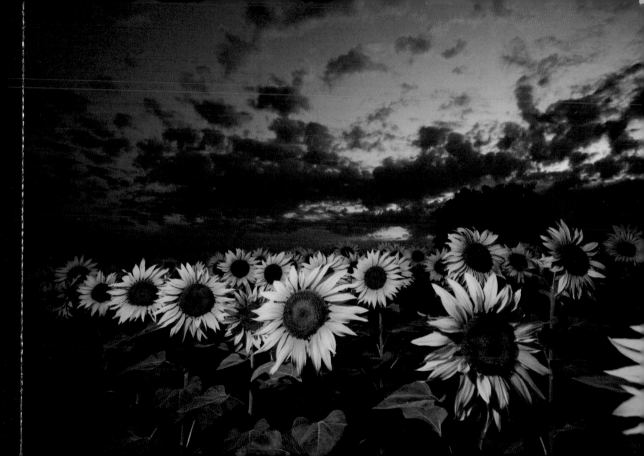

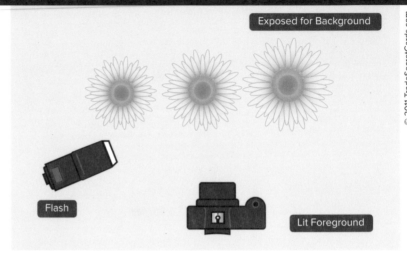

Exposed for Background

Flash

Lit Foreground

GARY WILLIAMSON

Sunflowers

THIS DREAMLIKE IMAGE by Gary Williamson was taken in a field just outside the airport in Geneva. He slowed the shutter down to 1/25 of a second at a 5.6 f stop to lock in the sky, and then brought up the flowers in the foreground with just a single flash camera left. Exposing for the background and lighting for the foreground can help turn a simple setup into a powerfully good image, especially when Mother Nature plays along.

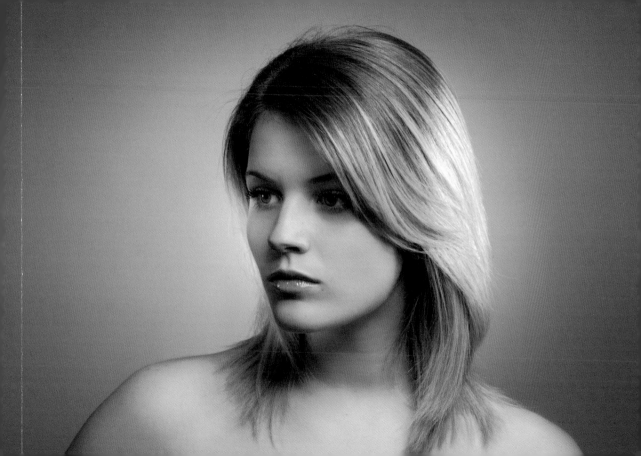

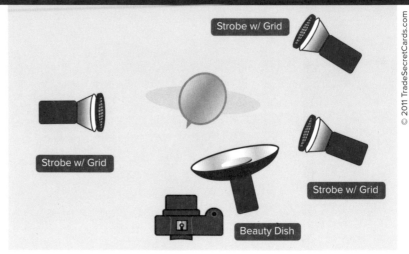

JEREMEY BARRETT
Soft

JEREMEY BARRETT'S IMAGE titled "Soft" doesn't actually use a soft box. So how does he get such a soft light? A 22-inch beauty dish, that's how. Pop a decent beauty dish nice and close to your model and you'll get that pretty, soft light, too. Jeremey then brings in three more strobes, each with a grid. By restricting the light with grids, Jeremey gets that sculpted edge along the model's face as well as that circular glow on the background.

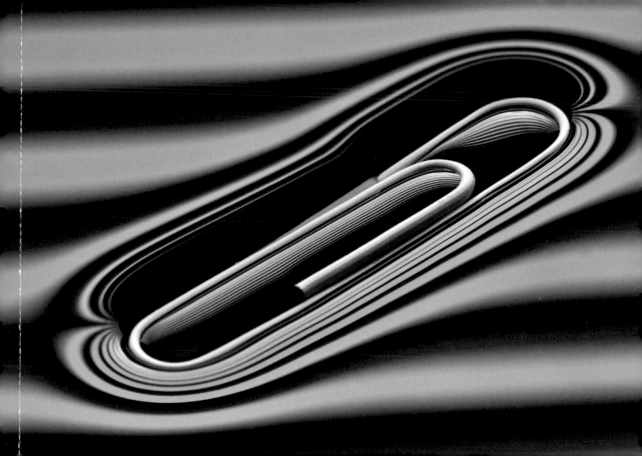

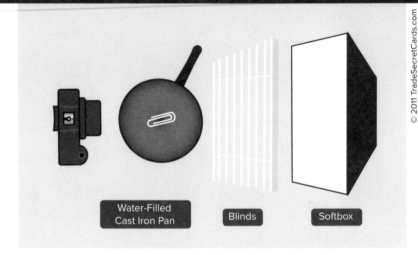

Water-Filled
Cast Iron Pan

Blinds

Softbox

JEFF DAVIS

Paper Clip in a Wind Tunnel

PAPER CLIP IN a Wind Tunnel is another clever example of brains over brawn. Jeff lit this shot with one strobed softbox. But in this case it's not the light that counts so much as the removal of light. By placing a set of window blinds between his subject and the softbox, Jeff created the graphic lines that twist as their reflection rides the curves created by the paper clip dipping along the water's surface.

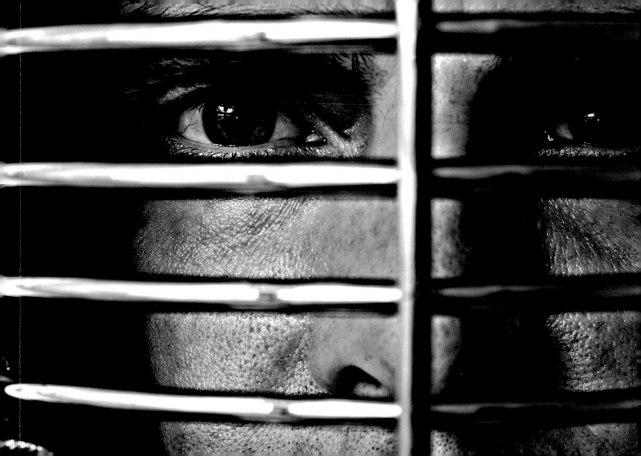

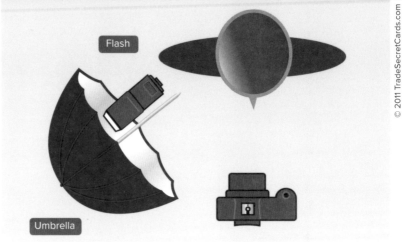

Flash

Umbrella

SEAN O.S. BARLEY
Grit

IF YOU ARE going to title a self-portrait "Grit," you're going to have to deliver a gritty look. Sean Barley brings that grit to his image with a single flash into an umbrella camera left. The side angle of the light divides the lines of the face mask into sharp highlight and shadow areas, creating that eye-catching pattern. More importantly, by raking the light across his face at an angle, the skin texture becomes sharply exaggerated, dramatically adding to the intensity of the image.

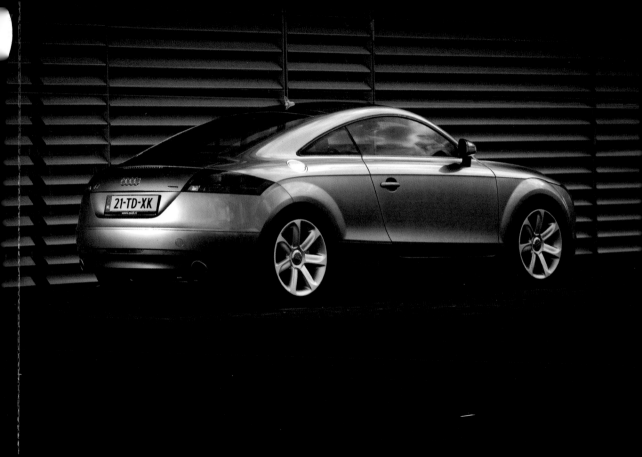

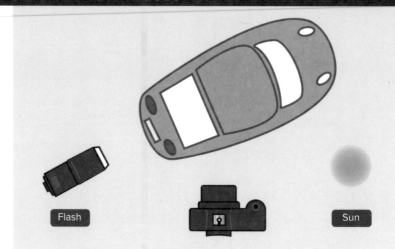

MARTIJN KOEVOETS

Audi TT 3.2 Quattro S-Tronic

WHO SAYS YOU need a light stand to shoot off-camera flash? Martijn Koevoets shot this car with the sun coming in from camera right. Then he added an off camera flash coming from camera left to bring the back of the car out from the shadows. Only he didn't use a light stand for the flash. He asked the car's driver to hold it. More brains = less gear. Don't let a lack of photo gear stop you from getting the shot you want.

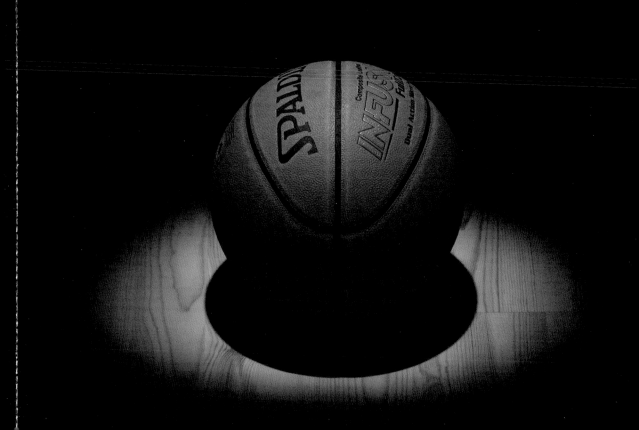

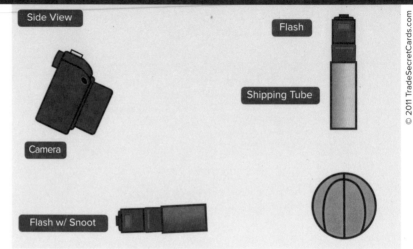

DAVE HOFFMANN

Basketball

DAVE HOFFMANN USED a shipping tube to deliver a photograph that pops. To create this dramatic image Dave fired one flash straight down through a 15-inch cardboard shipping tube, creating a nice crisp spotlight feel on the basketball. This created a contrast from the hard light that put the lower end of the ball into near darkness, so Dave brought it back up by throwing a touch of fill at the bottom half of the ball from a snooted strobe low and upfront, so he wouldn't lose that spotlight effect.

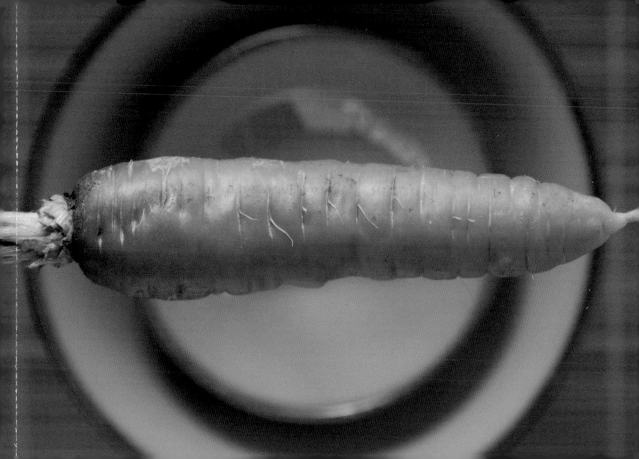

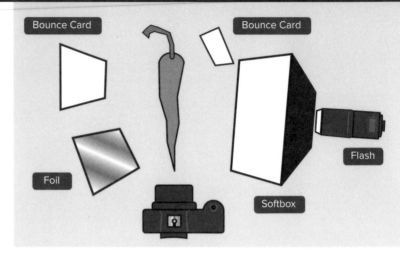

MATTHEW G. MONROE

Magic Floating Organic Carrot

MR. MATTHEW G. Monroe turned his boredom with the typical product shot into inspiration for the "The Magic Floating Organic Carrot." By bringing the carrot away from the background and using a short depth of field, Matthew keeps your eye where he wants it. Just one flash lights the scene. Aimed into a softbox camera right, the light spreads out to hit the bounce cards and a piece of foil. The foil helps bring some snap to the bottom rim of the orange veggie by changing the quality of the light.

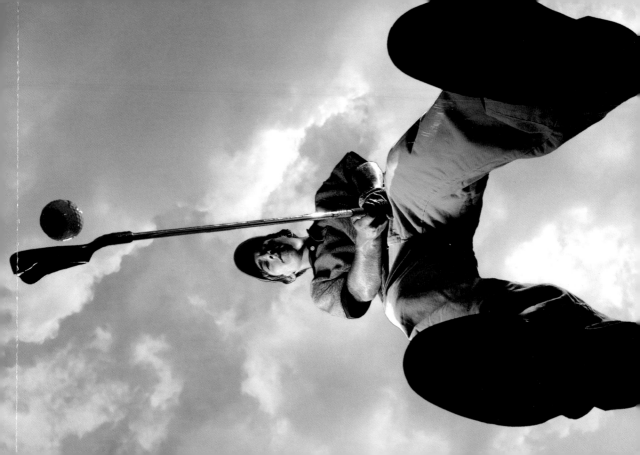

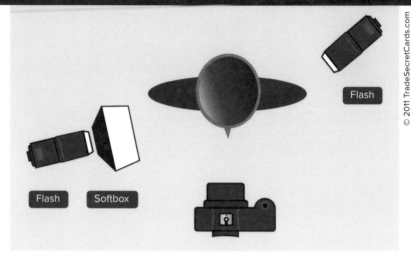

EVAN CATE

Calm Before The Storm

WHEN EVAN CATE risks life and limb by standing his subject over him on a piece of Plexiglass, he makes sure the lighting will pay off. For "Calm Before The Storm" he used a small D.I.Y. softbox camera left to help over-power the ambient light. Then he clamped a bare flash high up on a ladder for a touch of rim light. A little help from Mother Nature's cloud cover adds the finishing touch. It's lighting anyone can try, but please DON'T suspend your subjects above you without the help of trained professionals.

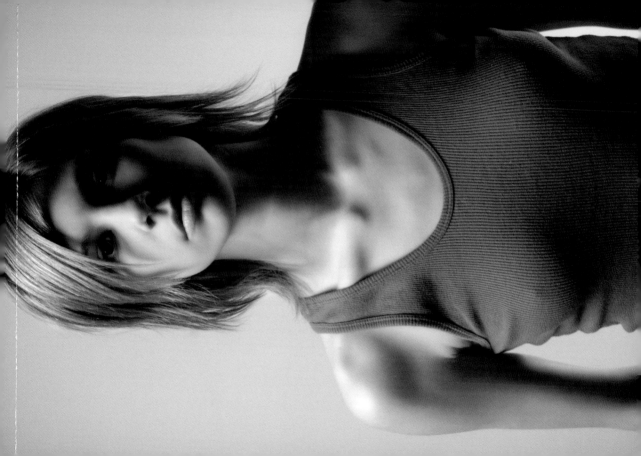

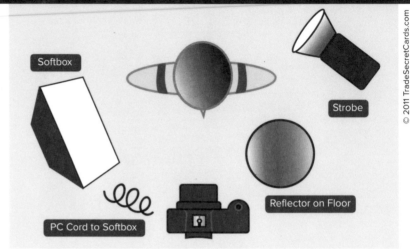

LUKE COPPING

Marie

LUKE COPPING'S PORTRAIT titled "Marie" uses a softbox high up to camera left triggered by a PC/sync cord. Luke lights the background with a strobe triggered via an optical slave. A silver reflector at the model's feet completes the package by reflecting the light from the softbox back up to add dimension to the model's jawline. Sometimes a little bounce can add the perfect touch. Plus, reflectors never run out of batteries.

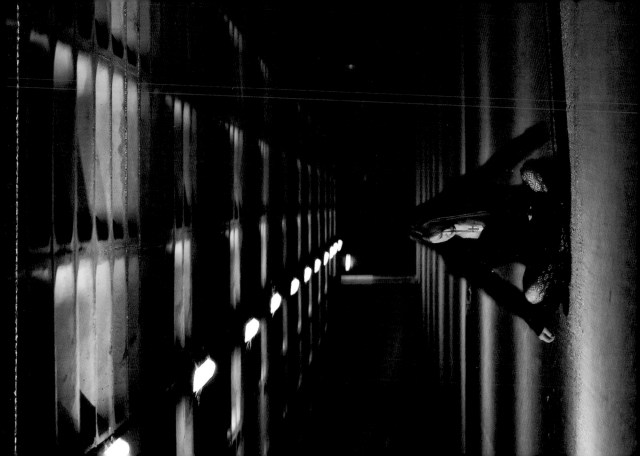

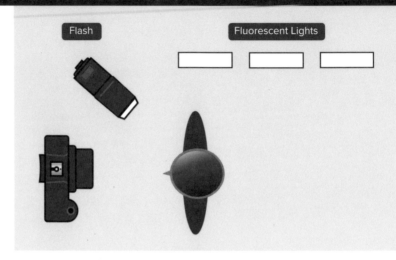

Flash

Fluorescent Lights

DANNY PACK

Isolate

TAKE ONE GLOOMY British car park, a Goth-clad model, a photographer with an eye for composition, and a flash with a CTO gel and you've got the makings of one eye-catching photo. For "Isolate," Danny Pack set his camera's color balance to the warm side of tungsten and used the CTO gel on the flash to help with the color cast. By lining the light up just right, Danny gives it the effect of a "practical light" or light that closely resembles real life. That's just how the big shots at the movie studios do it, too.

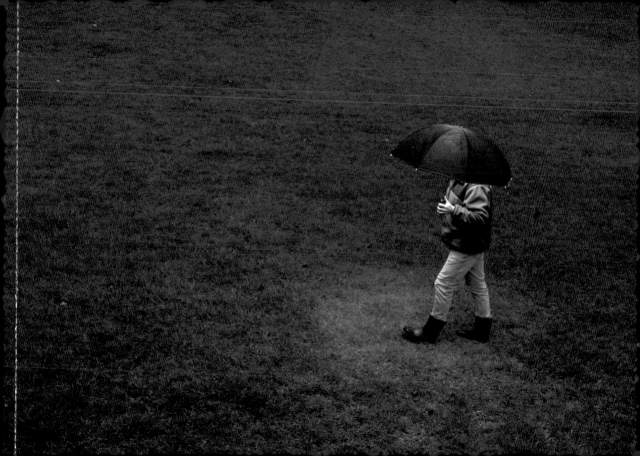

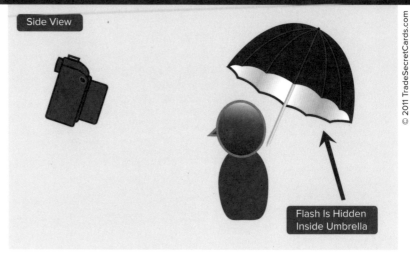

Side View

Flash Is Hidden
Inside Umbrella

PAUL DUNCAN

Umbrella Bounce In Your Stride

AN INEXPENSIVE FLASH and wireless trigger was all it took to turn a stroll in the park into a clever, graphically interesting image. In his photograph "Umbrella Bounce In Your Stride," Paul Duncan takes a funny idea and elevates it to a great photograph by powering the flash above the ambient and firing it into the underneath of his umbrella. Too much power and the idea would have fallen apart into an overexposed mess, too little and it wouldn't draw the eye.

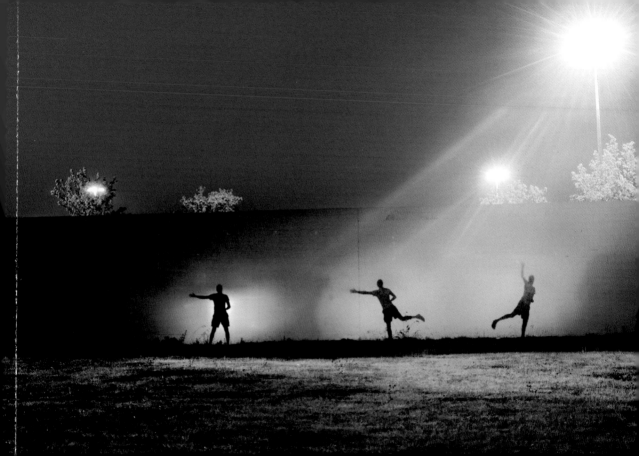

Street Lamp

Wall

Flash Flash Flash

One Subject
w/ 1 Flash
Popped 3 times

Long Exposure

JONATHAN BAGBY
Untitled

ONE LONG EXPOSURE and a cheap flash are all Jonathan Bagby needed to create this interesting image. No, those silhouettes aren't painted on the wall. Jonathan locked the shutter open on his camera. Then he fired the flash into the wall with his body between camera and light, creating that perfect cut out. Three poses. Three pops of the flash. The trick to this technique is the object you want to splatter your silhouette across needs to be as close to black as you can get it before you start.

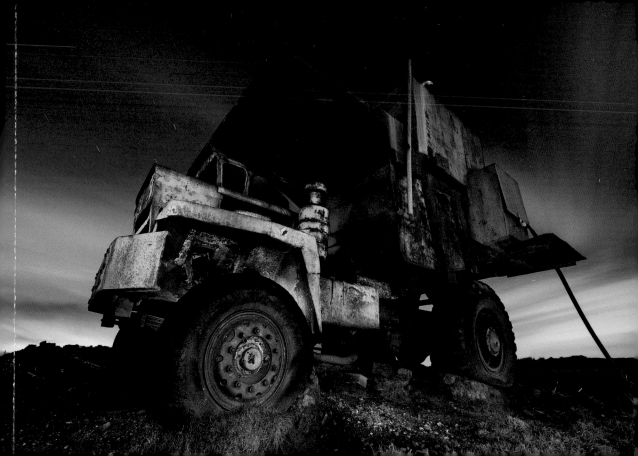

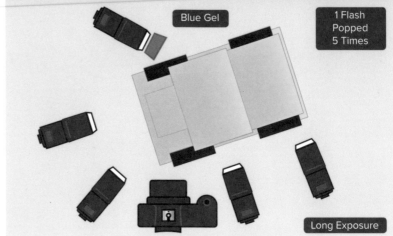

Blue Gel

1 Flash
Popped
5 Times

Long Exposure

STEVE SHARP

Loaded

STEVE SHARP LOCKED his shutter open for six minutes to capture his image "Loaded." Six minutes not only nailed the sky's beautiful colors, but also gave him time to pop his flash off several times as he ran around the truck. He even had time to sneak a blue gel over the flash when he lit the cab section. The low camera angle and wide lens complete the package, bringing the old clunker back to life in a cool and eerie way.

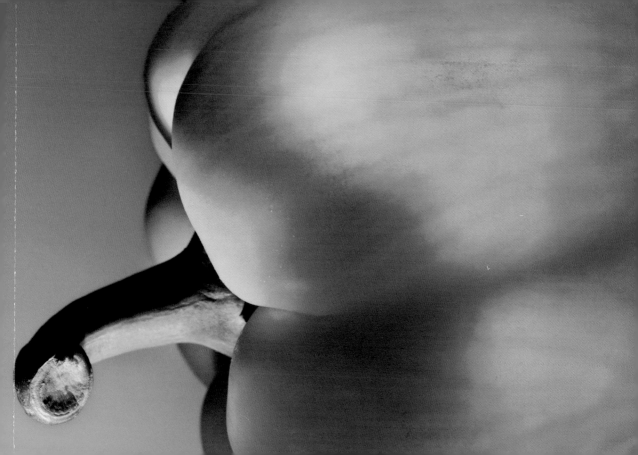

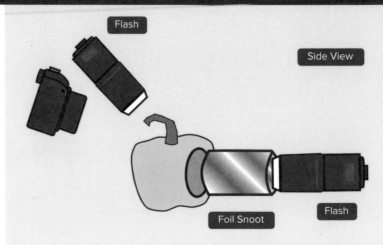

Flash

Side View

Foil Snoot

Flash

JOSHUA STEINKE

Yellow Pepper

WILL PHOTOGRAPHERS STOP at nothing to get the shot? Joshua Steinke cut open this defenseless pepper in order to light it from the inside with flash shot through a snoot made from tinfoil. Another flash shot through a snoot made from a breakfast cereal box lights the stem from the outside left. Illuminating it from the inside, the pepper acts as its own gobo, keeping the light from polluting the shadowy creases above and creating a wonderfully three-dimensional image.

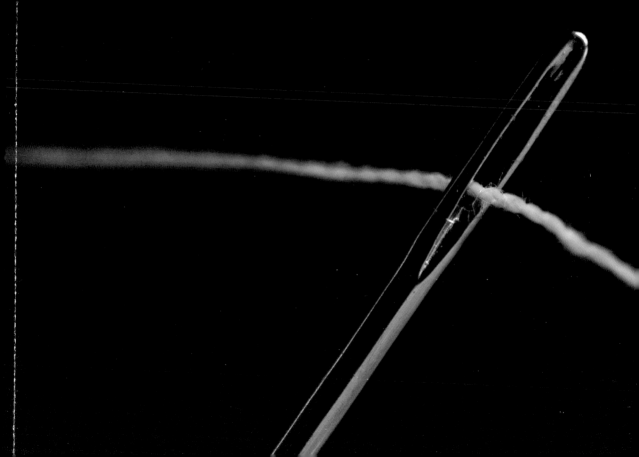

Flash

Shoot-Through Umbrella

Side View

PABLO ARELLANO MARCELO

Pinhole

ONE SMALL FLASH and a shoot-through umbrella was all the gear it took to get "Pinhole" looking just the way Pablo wanted it. He moved the umbrella up close enough to the needle to create a large white reflection and a ton of soft light. Pablo borrowed a macro extension tube from his "bro-in-law" so he could focus in nice and close, creating an abstract from reality and very cool-looking graphic image without the need for a complicated or expensive light setup.

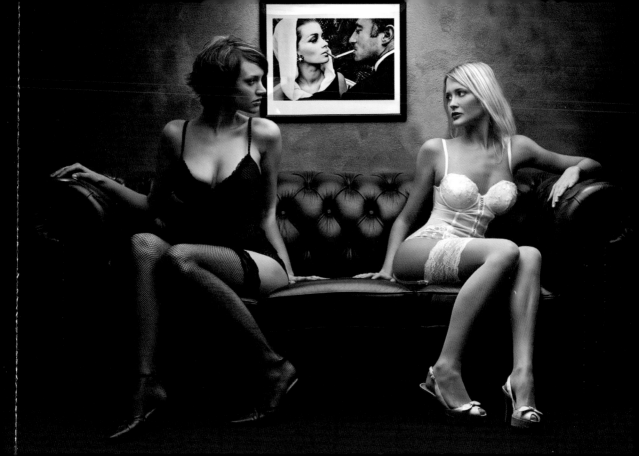

Octabox

PETER KREMZAR
Untitled

WHAT'S THE FIRST thing you think of when you see two Slovenian girls dressed only in their underwear hanging out at a bar? Seven-foot octa-box. Right? That's what Peter Kremzar was thinking when he set up this eye-catching portrait. Peter took the giant, rounded softbox and put it on axis with the camera but slightly above, bathing the models in supersoft light. The close proximity of light to subject created the dramatic dropoff from light to dark both on the subjects and the background.

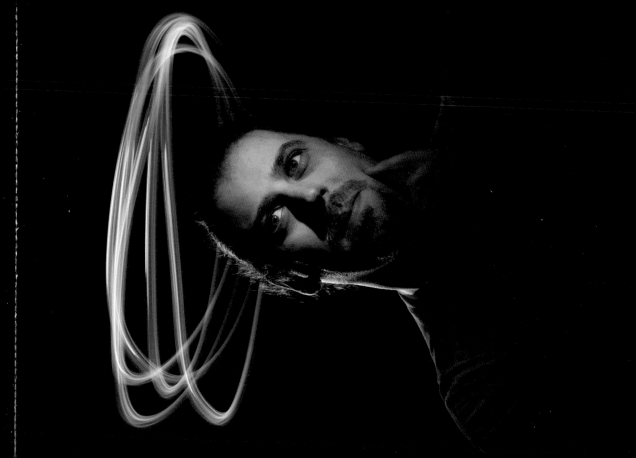

ADAM BENJAMIN
JOHN SMIRNIOS

Pondering Control

IT'S THE THOUGHT that counts. Adam Benjamin and John Smirnios wanted to put their newly acquired Strobist skills to use. Keeping the subject a fair distance from the background gave them the black backdrop they were after. Then they built the light up on Adam with a flash from the front through a D.I.Y. cardboard grid and a snooted flash from the back for separation. They left the shutter open long enough for John to "paint" in the curious circle overhead with an LED flashlight, and a great image was born.

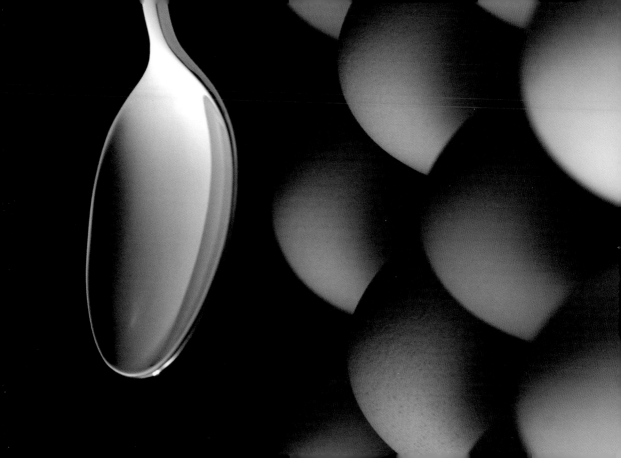

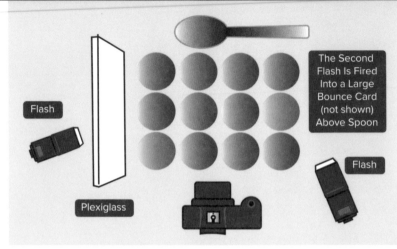

Flash

The Second
Flash Is Fired
Into a Large
Bounce Card
(not shown)
Above Spoon

Flash

Plexiglass

SAMUEL GRAY

Egg and Spoon

COMPLICATED LIGHT SETUP? Nope. This image uses just two flashes: one fired through a small piece of frosted Plexi to create the soft light that wraps around the eggs, the other bounced off a large white card above the spoon to give it that mirrored look. It seems the most complicated part of making the image was getting the eggs to stand up without seeing the egg carton. Samuel's solution? He tossed the carton and stood the eggs in a baking dish filled with sand.

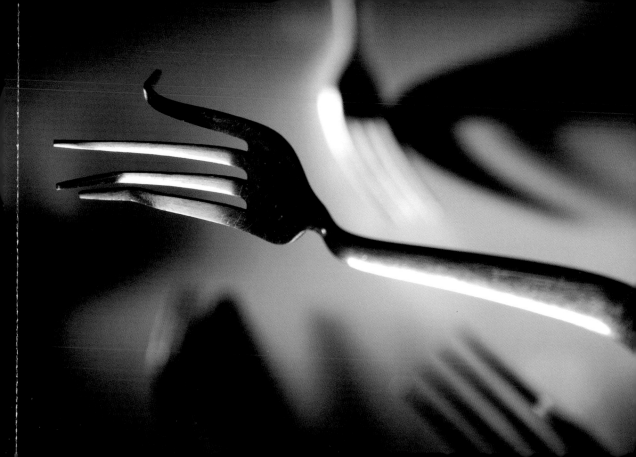

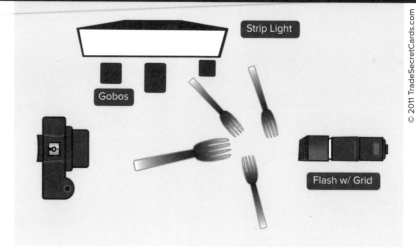

NORMAN MONTIFAR

The Petrified Diner

WHO WOULD TRASH a perfectly good fork just to make a perfectly interesting photograph? Norman Montifar, that's who. By bending and twisting the fork for his image "The Petrified Diner" he implied a story, a life the fork lived before the image was shot. To light it he used a D.I.Y. strip light and a few gobos to get his desired reflection on the fork. Then he backlit the other forks with a gridded second flash, creating the long shadows that add to the drama of the brutalized cutlery.

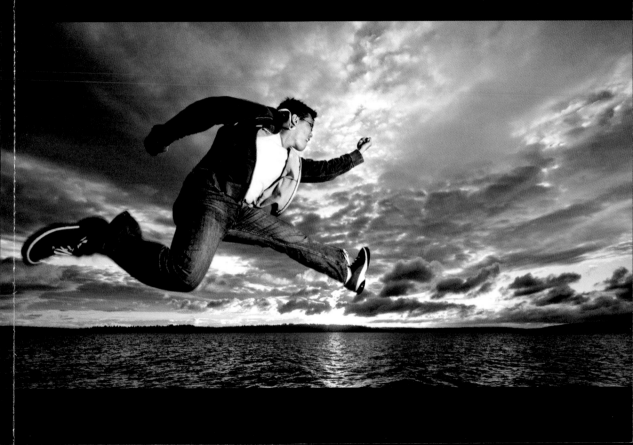

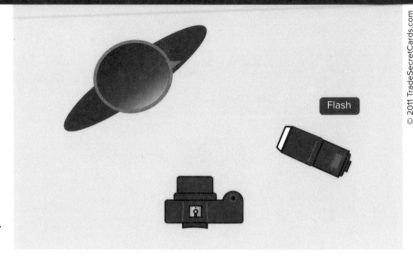

Flash

DANNY NGAN

Practicing My Running-Over-Water Skills

JUST A SINGLE bare flash at one-quarter power brought Danny Ngan's idea to light. The idea? He wanted it to look like he was running over water. To achieve this he used a circular polarizer to bring out the clouds and knock the reflection down on the water. Then he set up a low camera angle to keep the ground from view. But the most important part of this kind of shot has to be the timing it takes to capture a self-portrait at just the right moment. Yep, it's a self-portrait. Pretty tricky.

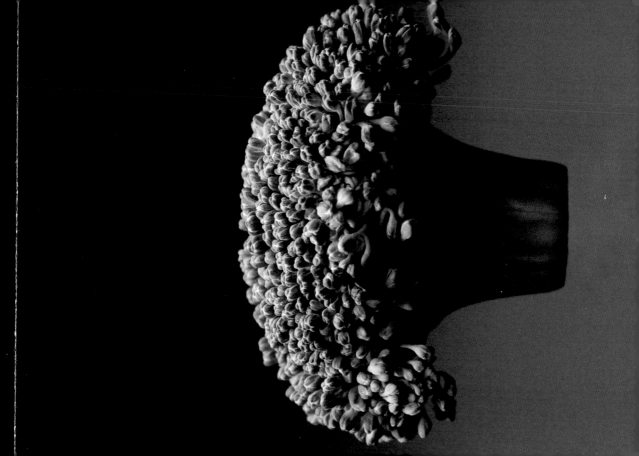

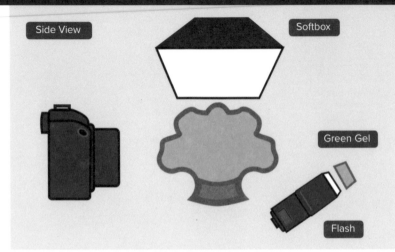

Side View

Softbox

Green Gel

Flash

JOSHUA TARGOWNIK
Untitled

TO BRING OUT the beauty of a lonely broccoli crown, Joshua Targownik used two strobes. One strobe lit the broccoli from directly above with a 15x15-inch softbox, large from the broccoli's point of view. The second strobe gets a green gel and a little gobo action before it is aimed at a white curtain to create the complementary background. Together the contrast, color, and texture create an image that looks as good on a wall as it would on a plate. Better even.

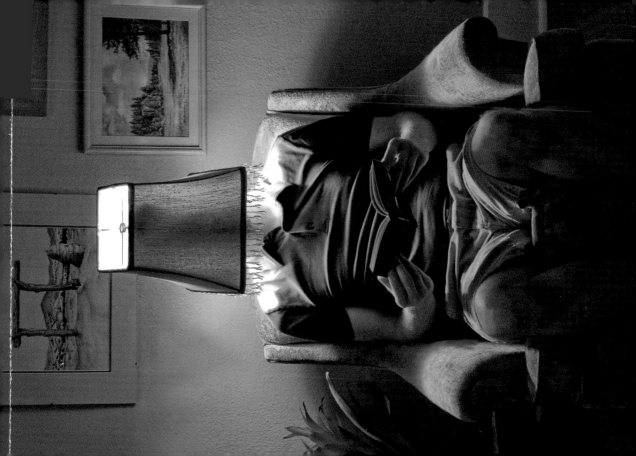

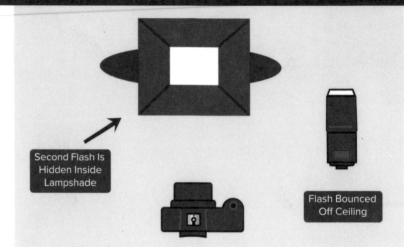

Second Flash Is Hidden Inside Lampshade

Flash Bounced Off Ceiling

JOHN SUMROW

The Reading Lamp

INSPIRED BY PAUL Duncan's "Umbrella In The Field" photograph, John Sumrow took it indoors and put a lampshade on his head. To capture this comic self-portrait John bounced a flash off the ceiling to create some fill light. But the money for this image is under the lampshade: a flash tied to his head with a ball bungie and diffused with a coffee filter. Clever or crazy? John said the ball bungie took a few hairs with it when he took it off, but it was worth it. I think you'll agree.

Photo © John Sumrow johnsumrow.com